CAMERA BAG COMPANIONS™

Digital SLR
Color Photography

D0942926

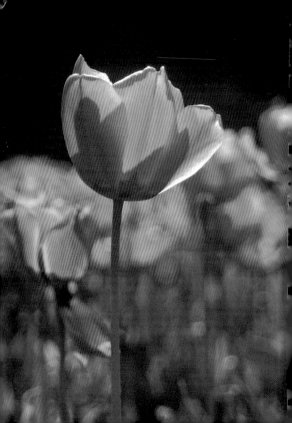

Digital SLR
Color Photography

CIDER MILL
PRESS

BOOK
PUBLISHERS

CIDER·MILL
PRESS

BOOK
PUBLISHERS

Visit us on the web at
www.cidermillpress.com
or write to us at
12 Port Farm Road
Kennebunkport, Maine 04046

The Ilex Press, 210 High Street ,
Lewes, East Sussex, BN7 2NS, UK

www.ilex-press.com

Copyright © 2010 The Ilex Press Limited

Publisher: Alastair Campbell
Creative Director: Peter Bridgewater
Managing Editor: Chris Gatcum
Editor: Steve Luck
Art Director: Julie Weir
Senior Designer: Emily Harbison
Designer: Ginny Zeal

Library of Congress Cataloging-in-Publication Data:
A catalog record for this book is available from the Library of Congress.

ISBN 978-1-60433-118-9

Printed and bound in China

■ CONTENTS

Color in Photography

The first known color "photograph" is attributed to the Scottish physicist and mathematician, James Clerk Maxwell, who created a color image of some tartan material in 1861 by shining red, green, and blue light through three separate transparencies of the material onto a wall.

The fact that any color image could be created out of just three colors forms the basis of how today's digital cameras and computer monitors record and display color, as well as being the basis of human perception of color.

Color in photography can be remarkably powerful. Color affects us in many ways, not least of all emotionally; and although volumes have been written about our responses to individual colors and their often symbolic significance, we still find it very hard to put into words exactly how color can affect us.

The purpose of this guide is to provide a handy reference on color and digital photography. As well as explaining how you can get your camera to capture color as accurately as possible, also covered in some detail are both individual colors and groups of colors, both harmonious and discordant, and what impact they have in photography.

Color in nature has developed over millions of years of plant and animal evolution. Colors are used to both attract and warn off, and the human response to color is complex and profound. When used successfully in photography, color—perhaps more than any other element—is capable of eliciting a powerful reaction.

The Color of Light

Light is part of the electromagnetic spectrum, which also includes radio waves, microwaves, X-rays, ultraviolet, and infrared. But unlike the majority of the electromagnetic spectrum, light is the visible part of the spectrum, and often referred to as the visible spectrum.

Historically, the visible spectrum has been divided into seven identifiable colors—red, orange, yellow, green, blue, indigo, and violet, with infrared and ultraviolet creeping off into the realms of invisibility at either end of the spectrum. Together, these colors, each with their own wavelength, make up white light, but can frequently be seen in their individual state through the diffracting properties of a rainbow.

Rainbows are atmospheric phenomenon caused by white light from the sun diffracting as it passes through fine drops of rain. The rain acts like a prism and separates the white light into its individual color components.

The electromagnetic spectrum is infinite, but even the "useful" range for us, from X-rays and gamma rays to long-wave radio, is many times larger than the visible spectrum, from about 400nm to about 700nm

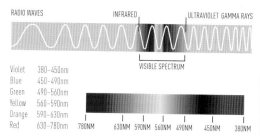

RADIO WAVES INFRARED ULTRAVIOLET GAMMA RAYS

VISIBLE SPECTRUM

Violet	380–450nm
Blue	450–490nm
Green	490–560nm
Yellow	560–590nm
Orange	590–630nm
Red	630–780nm

780NM 630NM 590NM 560NM 490NM 450NM 380NM

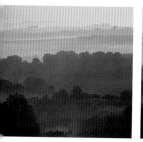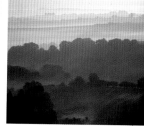

This photograph was taken on a September evening as the sun was setting, creating a warm orange light that viewers will respond to in a variety of ways. The version on the right has been "corrected" using an Auto Color command. This has stripped out the red color cast, creating a far less striking image.

RGB Color Model

The RGB color model is central to digital photography. The model is based on the three primary colors of red, green, and blue. When added together in varying degrees these colors are capable of producing almost all the colors the human eye can detect, hence they are often referred to as the "additive" primary colors.

A camera's sensor is not able to distinguish color on its own, only the intensity of light, and so in order to capture a color image, a color filter array (CFA) is placed on top of the sensor. The CFA is a matrix of red, green, and blue squares (with twice as many green squares as either of the other two colors as our eyes are most sensitive to green light). As light from the scene passes through the CFA to the sensor it is broken down into red, green, and blue components. Through a sophisticated interpolation process known as "demosaicing" the camera's processor "rebuilds" the full array of colors and the color image is recorded.

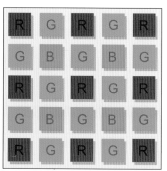

This is the most common pattern of color filters used in a digital camera's sensor. In a typical color filter array (CFA), 50% of the filters used are green, 25% red, and the other 25%, blue. More green filters are used as they mimic the way the human eye works and therefore help produce a sharper image.

RED CHANNEL

GREEN CHANNEL

BLUE CHANNEL

All digital color photographs are made of the three color channels red, green, and blue, which combine to make up a full-color image, as shown here.

11

How Many Colors?

All digital information is based on the binary counting system, and digital photography is no different. The binary counting system uses only two digits, 0 and 1. In computing 0 and 1 can be used to represent "off" and "on" respectively. In digital photography 0 represents black and 1, white. This is referred to as a 1-bit image.

But of course photographs are made up of more than just pure black and pure white. What happens if we double to 2-bit? In this case, black would be represented by 00 and white by 11, and we now have two grays in between, 01 and 10. But again this will not provide anything like the necessary shades of gray we need to obtain a smooth monochrome image. In fact, to achieve this we need to go to 8-bit. At this level of information, with black represented by 00000000 and white by 11111111, there are 254 individual shades of gray. With a total of 256 tones (including pure white and pure black), we get what is referred to as a continuous-tone grayscale image.

By the time we get to the level of 8-bit, there are 2 56 distinguishable tones, including pure black and pure white. With this number of grays available, monochrome images look as if they are made up of continuous tones.

Multiplying the 256 available tones in an 8-bit image, by the three color channels results in 16.7 million different colors.

We know that cameras use a colored filter to enable the sensor to capture the colors in a scene. We also know that the filter comprises three different colors—red, green, and blue. If we apply the same 8-bit level of information to each of the three colors, so that 00000000 represents no color (in other words black) and 11111111 represents 100% color, for example pure blue, then it follows we have 256 tones of blue, 256 tones of red, and 256 tones of green, which together make up (256 x 256 x 256) 16.7 million different combinations of red, green, and blue, or, put simply, 16.7 million different color states. More than enough to create a continuous-tone color

16-bit color

The Raw file format (see pages 90-91) is capable of storing 16-bit images, which in theory can have trillions of color states. Again, these can't be detected by the human eye, but when it comes to editing images and adjusting color, you're far less likely to end up with "banding," or steps, when one color jumps to another. This is often visible when you edit an 8-bit image with a graduating blue sky. The sky appears to have different shades of blue bands, whereas a 16-bit image will provide a more subtle tonal gradation.

Color Temperature

Whether you read this book by candlelight, a desk lamp, or midday sunlight, the paper will always look white. In reality, though, each of these light sources has a different color, known as its color temperature. The reason we don't see this is that the brain automatically compensates for these differences, and thus we see the white that we expect to see.

Light comes in a huge range of different colors, and it is only at the most extreme ends of the scale that the human eye can perceive the difference. A sunset, at one end of the color scale, will look orange; a clear sky, which is a light source in its own right, looks a deep blue.

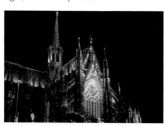

Different artificial lights have a wide range of colors. The lights illuminating Cologne's magnificent cathedral have a visible green tint.

The color of the sunset is deeper or redder on some occasions more than others, due to there being more particles in the atmosphere at these times.

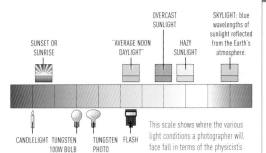

OVERCAST SUNLIGHT

SKYLIGHT: blue wavelengths of sunlight reflected from the Earth's atmosphere.

SUNSET OR SUNRISE

"AVERAGE NOON DAYLIGHT"

HAZY SUNLIGHT

CANDLELIGHT TUNGSTEN 100W BULB TUNGSTEN PHOTO LIGHTING FLASH

This scale shows where the various light conditions a photographer will face fall in terms of the physicist's temperature scale, Kelvin.

Color temperature is commonly measured in degrees Kelvin (K), and this scale is provided on all digital SLR cameras as a way of manually setting up the camera for particular lighting conditions. However, digital SLRs also have a number of preset settings of common lighting situations, such as "sunny," "shady," and "incandescent," which will make sure white is recorded as white. They also have a setting that attempts to automatically allow for any color bias that might be present in any given lighting situation. This is known as Auto white balance or AWB.

The sky looks blue due to wavelengths of light bouncing back toward us from Earth's atmosphere.

White Balance

Essentially, white balance is concerned with the overall color of the light in which you're shooting. As we know, light at the time of a dramatic sunset will have a distinctly reddish color cast to it, while interior lights—such as certain incandescent lights—can give off an orange glow. Our eyes are so good at adjusting for such color casts that we often aren't aware of them. But for a digital camera, unless the color of the lighting is addressed, whites will not appear as whites, hence the term "white balance." In the case of the sunset, whites will appear rosy pink (which may be acceptable), while under incandescent light, white can appear orange (usually far from desirable).

Display	Mode	Color Temperature (Approx K: Kelvin)
AWB	Auto	3000–7000
☀	Daylight/Sunny	5200
🏠	Shade	7000
☁	Cloudy, twilight, sunset	5000
💡	Tungsten light	3200
🔲	White fluorescent light	4000
⚡	Flash	6000
⬗	Custom	2000–10,000
K	Color temperature	2500–10,000

Every type of light has a color-temperature value, which is expressed in degrees Kelvin. Digital SLR cameras have a number of preset white balance settings for common shooting situations (shown left), which will help to make sure that white is captured as white, and therefore other colors will be accurate.

Using the camera's Auto White Balance (AWB) setting will usually provide pretty accurate results, and this is the best setting to leave the camera on. However, in extreme conditions you may need to turn to one of the white balance preset settings to get more faithful-looking colors.

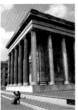

AUTO

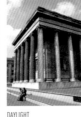

DAYLIGHT

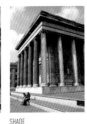

SHADE

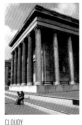

CLOUDY

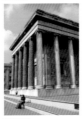

TUNGSTEN

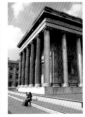

WHITE FLUORESCENT

These images show how the same scene is rendered differently with different white balance settings. Although you wouldn't want to apply an inappropriate white balance setting, these comparative images show the effect the white balance settings have.

Advanced White Balance

Here's a quick and easy tip if achieving accurate white balance is important in difficult or mixed lighting situations. Select your camera's manual or custom white balance setting (most digital SLRs now have one of these). Next, place a white object in front of the camera so that the camera can record how white will appear under the particular lighting conditions you're working in at that time. With some cameras it's simply a case of making sure that the white object—a piece of white paper or card will suffice—fills a good element of the viewfinder (the spot circle for example), and then taking a shot. The camera will record the white balance setting, which will then become available as a custom preset in the white balance menu when you continue to photograph. With other cameras simply pressing a white balance button will record the white card and apply that setting to future shots. Check in your manual to see how your specific camera's custom white balance setting works. "Gray cards" are also commercially available, and can be used in place of the white piece of paper.

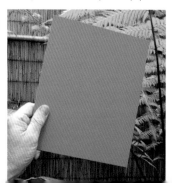

The ever-useful gray card is a simple means of checking color balance objectively; this version is from Kodak. Photograph it under the lighting conditions in which you're shooting and you'll be able to set a manual white balance that will provide accurate white under those specific lighting conditions.

Look for gray reference

Most scenes will have at least one small area of neutral gray in them somewhere (here shown by the red circles). You can use this as a reference point as a way of getting fairly accurate white balance—particularly if it's not practical to shoot a white or gray card to set a custom white balance at the time of shooting. Make a mental note of the gray object or area, and when you edit the image in post-production you'll have a reference color to work to. Shooting in Raw will provide the best results if you do later need to adjust the color.

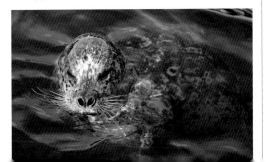

Skylight

Skylight is the term given to light that is reflected from the sky (as opposed to light that emanates directly from the sun, which we know as sunlight). Historically, skylight was the preferred lighting for artists who believed it to be a very consistent light source, and much softer than sunlight.

In reality, however, skylight gives off a blue color cast due to the scattering of short wavelengths in the atmosphere. This is most noticeable in shade, where skylight tends to be the only light source. We perceive it as a consistent neutral color, but it can in fact be quite blue. That's why digital SLRs have a "shade" white balance setting that has an associated color temperature of around 7000K–8000K.

In mountains and in clear weather, there is less atmosphere, less haze, and more ultraviolet. The skylight in these conditions will provide a noticeable blue color cast, especially with any images taken in shady conditions.

The color temperature of skylight covers approximately the range shown here. In the first panel, the atmospheric conditions are clear and dry; the intensity of the blue depends on altitude, season, position of the sun, and which part of the sky you look at (normally the higher, the more intense). In the second panel, the blue is diluted by increasing amounts of haze. Broken cloud in the third panel reduces the overall color temperature; this varies with how bright the clouds are and how much of the sky they cover. Finally, the surroundings may obscure some or most of the skylight, and if they are pale in color and sunlit themselves, they can virtually take over as the light source

CLEAR SKY
12,000-7,000K

HAZE
ABOUT 6,000K

VARIABLE CLOUD
ABOUT 5,700K

PALE SURROUNDINGS
ABOUT 5,400K

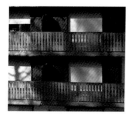

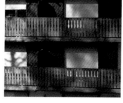

The blue color cast of this image showing the white blinds of a ski chalet in shadow is quite distinct. Selecting the Auto Color command (right) significantly warms up the image.

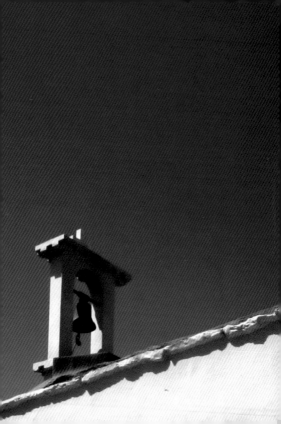

Sunrise and Sunset

The height of the sun in a clear sky will have a profound effect on your photographs—not least in terms of color. Over the next few pages we'll examine exactly what the effects are at various heights, and how you can use them to your best advantage.

We are all familiar with low sun—when it is around 20–30 degrees above the horizon—and the colors associated with it. Photographs of sunsets abound, almost to the point where they are now considered something of a cliché by many. Cliché or not, however, they are still a firm favorite of postcard sellers all over the world—with warm reds provoking an almost visceral response, with connotations of lazy vacations by the ocean. When shooting a sunset, avoid a flat featureless horizon, look instead for a scene that has some interest in it.

Of course it's not just the sunset (or sunrise) itself that makes for such popular photographs. The light at this time of day is suffused with pale oranges, reds, and pinks that will reflect off just about every surface.

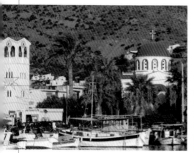

This shot of a Greek harbor was taken very early in the morning when the sun was still low in the sky. The boats and buildings clearly show the red color cast in the light.

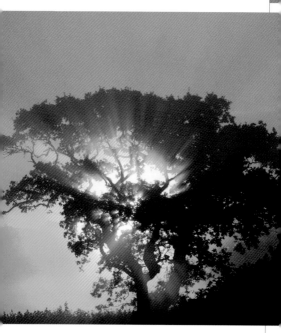

Photographs of sunsets or sunrises, despite their popularity, can still conjure up a powerful response in the viewer. Here the sun is partly obscured by a tree, creating dramatic rays as the sunlight passes through the branches. Underexposing slightly will create richer colors.

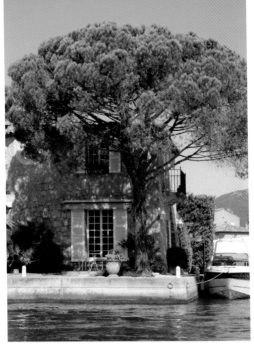

Colors in the morning and afternoon, when the sun is higher in the sky, are much more neutral than they are just after sunrise or sunset. However, with the light traveling a shorter distance through the atmosphere than at the ends of the day, it can often have a slightly harsh, less flattering quality.

Morning and Afternoon

Although not as overwhelmingly dramatic as the light that is often encountered at sunrise or sunset, that of mornings and afternoons, when the sun is at least an hour above the horizon, has much to recommend it.

In terms of color, light at this time of day is much more neutral than at sunrise or sunset, making it a far more preferable time to shoot if accurate color rendering is important. However, compared with the harsh light of midday, morning and afternoon may still have some softness, particularly if conditions are still a little hazy, as they can be in the morning.

As well as being a good time to shoot in terms of providing neutral color, the relatively low sun of the mornings and afternoons also allows you to choose which angle you want the light to strike the subject, which as we shall see over the coming pages has an important impact on your images.

Depending on the angle the light is striking the scene, colors in the morning can be rich and saturated. But this time of day is also notable for long modeling shadows, which show off an undulating landscape to its best advantage.

Frontal Lighting

With the sun about an hour or so above the horizon, and well before midday, you can position yourself so that the light is shining toward you, to one side, or behind you. Each of these three main lighting angles will impact on how color is captured in your images.

Frontal lighting is often shadow free and can create a rather flat, two-dimensional feel to your images. However, in terms of color, frontal lighting will provide uniform and rich results. Colors will appear bright and evenly lit; so if your image comprises strong, conspicuous hues, make sure the light is behind you to make the most of them.

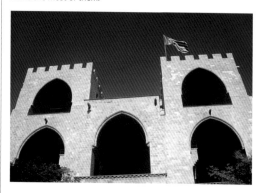

Frontal lighting will create the deepest colored skies in your picture, as in this shot of an ancient gatehouse in Spain.

However, the head-on lighting makes the structure look rather two-dimensional.

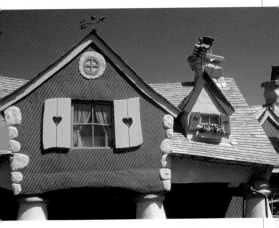

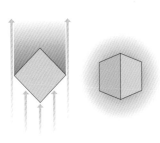

Shot at a theme park, the bright colors of this crooked house are shown with full intensity, thanks to frontal lighting.

With shadows usually cast behind the subject, frontal lighting provides even illumination across the visible surfaces, making it ideal lighting in which to capture strong, bright colors.

Side Lighting

With the light to the side of the camera or the subject, shadows tend to be cast across the surface of the subject itself. This provides the vital shading that gives the information about a subject's form and a surface's texture.

In terms of color, in the well-lit areas colors can be intense, but in the shadows they have a tendency to be drab or unnoticeable. So, while side lighting is excellent at providing a modeling light that gives information about an object's shape and can pick out texture, color rendering is uneven, ranging from very bright to very dark.

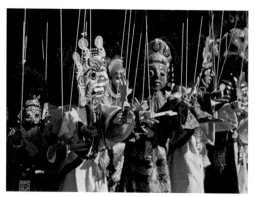

The variation in color intensity and interfering shadows means that sidelighting is less than ideal for complex scenes. It is hard to make out one puppet from another in this shot of a Nepalese store.

Strong sidelighting works well in this picture, accentuating the spherical shape of the grapes. Note also how leaves are green in lit areas, but not when in shade.

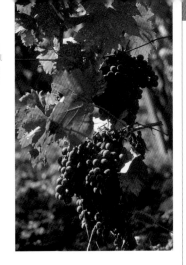

The main characteristic of sidelighting is the contrast caused between the areas that are lit and those that are not. The shading between the two gives all-important information about the three-dimensional shape. In addition, in those areas that are lit, colors will be bright, while in unlit areas, the colors will be flat.

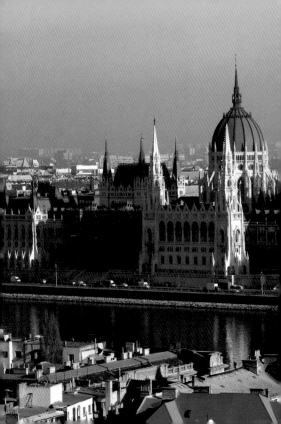

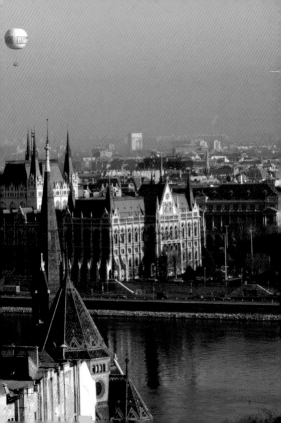

Back Lighting

When the lighting is facing toward the camera, the subject will tend to be completely in shadow, generally meaning that colors are subdued or lost. In fact, at the extreme, backlighting leaves you with a silhouette—a black outline that accentuates the subject's shape, but tells you little else about it. However, back light through a colorful translucent object can be a really effective way of emphasizing the subject's color.

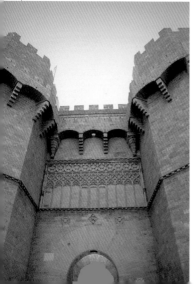

Lit by skylight and reflected light from the ground, the detail in the brickwork of this gateway in Valencia is soft and almost colorless.

When shooting into the light, there is always a risk that light rays from outside the image area will enter the lens and reach the sensor. At its worst, this flare can produce streaks of light across the image, including one or more polygonal pools of light that are the same shape as the lens's aperture. But sometimes flare goes unnoticed, as it simply softens the detail in the image. To avoid lens flare, try using the lens hood designed for your specific lens. Alternatively, place your hand in a strategic position in front of the lens so that a shadow is cast over it.

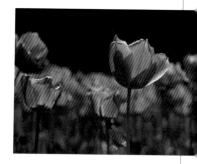

The normal rules for back lighting do not apply with translucent subjects. The light shines through the petals of these tulips, intensifying their color against the carefully chosen dark background.

With back lighting, the subject is thrown into shadow, as only the side that isn't facing the camera is lit. Detail is only visible if the facing side is lit indirectly. With the subject in shadow, colors will be drab and muted, so you should avoid back lighting if you're intending color to be a principal element.

High Sun

During the middle of the day, when the sun is high in a cloudless sky, light is at its most neutral color, and shadows generally are short. There are no natural warm tones or raking shadows along the ground to add atmosphere or drama at this time of day, and for many photographers it's an unappealing time to shoot. The lack of shadows in open country can result in flat-looking landscapes, while shots of people will result in shaded eyes and unattractive shadows running down the face.

However, the consistent and neutral light will result in accurately colored and crisp images containing clear and bright detail. Therefore, subjects with interesting form and color, such as some architecture for example, will come out well in this light.

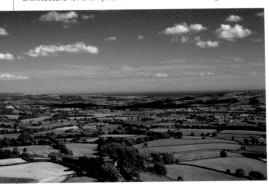

Despite the lack of any modeling shadows, this landscape is successful through its clarity of detail, far reaching view, and saturated, but neutral, colors.

This potentially difficult and confusing image to "read" has been made simpler thanks to there being no shadows to break up the architectural lines or partly obscure the signage. The subtle color palette has been accurately captured.

A high, uninterrupted sun creates a crisp, bright, and neutral light that shows off detail to its best advantage.

Twilight

Twilight is the light that is found in the sky either between night and sunrise, or sunset and night. The subtle diffusion of sunlight through the atmosphere is uniquely delicate, and can create very atmospheric images. Photos captured at twilight are usually most successful in a clear sky, when the subtle shading visible in the sky is shown at its best.

With light levels as low as they are during twilight hours, it's possible to shoot directly toward the light source without fear of overexposing the highlights. Under these circumstances, any objects will be rendered as a silhouette, so look for subjects with recognizable and pleasing outlines.

Experimenting with exposure at this time of day will impact the image in fairly drastic ways. A longer exposure will wash out colors near the horizon, but extend the blues into the sky, while reducing the exposure will intensify the colors nearer the light source.

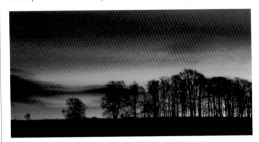

Clouds at twilight (above) can reflect dramatically a sun that's about to rise or, if unbroken, destroy the subtle light altogether. A clear twilight (right) sky acts like a smooth reflective surface with the sun lying below the horizon.

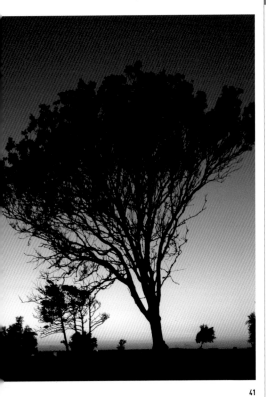

The Impact of Color

As discussed at the beginning of this guide, color can have a strong impact on your photographs, and in objects generally. Sometimes the impact may be emotional, but hard to pin down. Why exactly are photographs of sunsets so popular? Why is red traditionally considered the color of choice for sports cars? It's easy to understand why green is associated with nature, but is that why we also perceive it as symbolizing renewal and hope? And what of blue and yellow, what do they symbolize?

The way colors interact with one another also works on a purely visual level—reds advance, for example, while blues recede—meaning that if you had two objects the same size and shape, and one was red and the other blue, the red object would appear closer than the blue.

Over the next few pages, we'll look at individual colors in turn, and discuss the emotional and physical responses they elicit when used in color photography.

Everyday colors are rarely as saturated as they are in these ornamental wooden flowers, which is why bright, pure colors attract our attention, and why they are used in advertising and warning signs.

Red

Red is perhaps the most powerful of all the colors. It's associated with danger, in both nature and our manufactured world. Red is the color of blood, and so is often used in association with passion, anger, heat, and fertility.

From a visual perspective, when placed next to more subdued colors, most noticeably with blues and greens, red advances toward the viewer and successfully catches our attention. Additionally, red is recognized for its "vibration" effect, during which, when placed next to certain other contrasting colors, the edge between the two colors seems to flicker.

Vibration is one of a family of flicker effects that was popularized by the Op Art movement in the 1960s. Vibration occurs along the edge between two intense colors that contrast in hue, but are similar in brightness. Red is the easiest color to work with because of its richness. Staring at the edge for long enough will reveal a light and dark fringe.

In the United States (during Memorial Day) and in many Commonwealth countries (during Remembrance Sunday), the poppy is used as a symbol for soldiers who died in various wars, but most notably World War I. The association between the poppy's color and the blood shed on the battlefield is a powerful one.

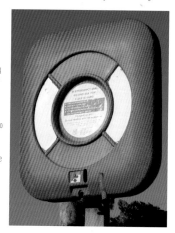

Red is widely recognized as an advancing color, in other words it stands out well against other cooler colors. For this reason, and for its association with danger, it is often used to color safety equipment such as fire extinguishers and buoyancy aids.

Green

The color of grass and leaves, green is inextricably linked with nature, and by extension symbolizes growth, renewal, and youth. On a less positive note, green's association with wealth has also transmuted into one of greed and envy, as in "green with envy," and jealousy, as in the "green-eyed monster."

From a purely visual perspective, green is the color to which our eyes are most sensitive, which is why the color filter arrays used in digital cameras to capture color, have twice as many green elements as either red or blue, the two other colors used in such arrays. Our sensitivity to green helps us to discern the color over long distances, which is why, together with the fact that it contrasts well with red, it is used in stop lights.

Green is the color of nature and symbolizes growth and renewal. For this reason the color is now widely used by ecological movements around the world, and is the color of choice during any discussion involving renewable energy.

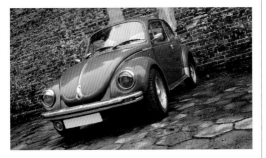

Green has long been a popular choice for car drivers who see themselves as cautious and responsible.

Green is the most visible color to the human eye, which is why it is used in a variety of traffic signs and in stop lights.

Greens

DARK GREEN

DARK OLIVE GREEN

DARK SEA GREEN

SEA GREEN

MEDIUM SEA GREEN

LIGHT SEA GREEN

PALE GREEN

SPRING GREEN

LAWN GREEN

GREEN

CHARTREUSE

MEDIUM SPRING GREEN

GREEN YELLOW

LIME GREEN

YELLOW GREEN

FOREST GREEN

49

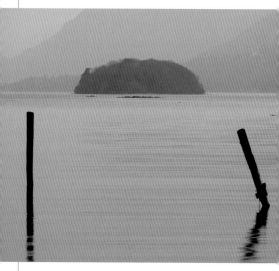

Blue

The color of the sky and, through reflection, also that of the ocean, blue is a tranquil, peaceful color—everything that red is not. Blue is associated with unity and harmony, but perhaps most significantly of all with cold. Whereas red is the color on the hot tap, blue is commonly found on the cold. A room painted blue is generally considered to feel colder than one painted any other color. Visually, blue is a receding color.

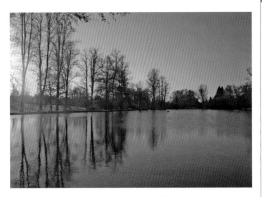

Blue is the color of the sky and water. Blue images tend to evoke tranquillity and calm, and often have a very cool feel to them. The image above was given an intentional blue color cast by using the white-balance control set at the incandescent setting.

In many countries blue is used in road signs that impart information, as opposed to red, which is used in warning signs.

Yellow

Yellow is often thought of as the color of the sun, and is the brightest of all the colors. For this reason yellow is closely associated with happiness and optimism, as well as light and gold. It is an energetic color and is often used to catch people's attention, hence its use in road sign and school buses in the United States. On a less positive note, however, too much yellow can lead to anger or aggression.

Yellow, unlike other colors such as green, has a very limited hue. Yellow is pure yellow, adding black will quickly see it forming either a green or brown.

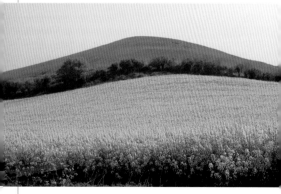

It's only the agricultural use of oil seed rape that sees large swathes of yellow in landscape scenes—the color is usually restricted to much smaller, more localized spots, such as fields of marigolds or artificial beds of daffodils.

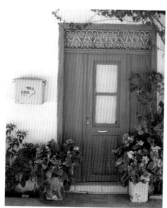

Yellow's simple brightness attracts people to use it as a paint whenever they want an object to stand out. In many countries in Europe, such as Greece, post boxes are painted yellow for this very reason.

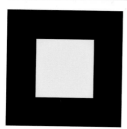

As the color squares demonstrate, a bright color such as yellow receives energy from a dark setting, but is drained by a pale one.

The central yellow square is identical in each. This has a real impact when photographing yellow objects.

53

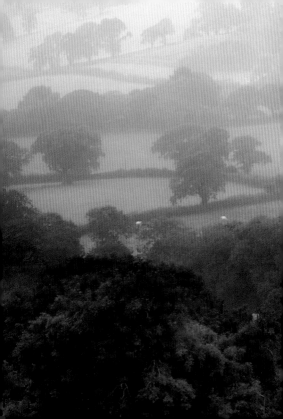

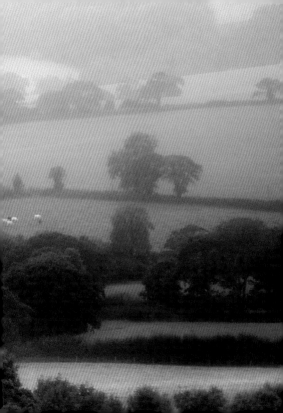

As well as being a plant, lavender is also a color definition in its own right, yet still falling in the broad range of violet as a secondary hue.

Traces of violet can occasionally be detected in the sky at sunrise or sunset, providing an ethereal quality; certainly less worldly than the more familiar oranges and reds commonly found at such times. This photograph was shot three minutes after the one on page 40.

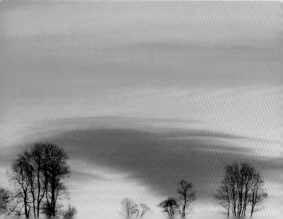

Violet

In color photography, violet, perhaps more than any color, is the hardest to pin down. Although a mixture of blue and red, two of the three colors in the RGB color model, violet is both difficult to capture with the camera and rarely accurately displayed on a color monitor. Photographing a number of different violet flowers and getting them to reproduce faithfully on screen reveals this to be so. In fact, we often find it hard to distinguish violet ourselves, the color often being confused with the more reddish purple or magenta, or when extremely dark as dark blue.

Violet is associated with metaphysics, magic, and in many cultures with religion, which is perhaps why a violet landscape is suggestive of mystery and "otherworldliness."

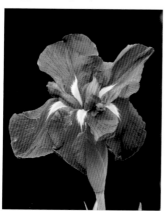

Shot against a very dark background, and slightly back lit, a violet itself demonstrates the elusive nature of the color. The colors here range from dark blue, through magenta and purple, to violet. The translucency of the petals adds to the confusion.

Orange

Being a combination of red and yellow, it's not surprising that orange is such an energetic and radiant color. It is less aggressive than red, and although not as bright as yellow, it retains much of that color's cheerfulness. Orange has a natural warmth that avoids the overbearing heat of red and the searing brilliance of yellow.

Orange is used widely as a color of celebration and festivity and also has strong religious associations, from Sikhism, Hinduism, and Buddhism in the East, to Protestantism in the West.

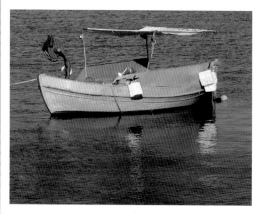

Orange, unlike yellow, has a wide range of hues, with some veering toward red and others veering toward yellow. Generally, its overall effect is to uplift the spirits with warm, vibrant tones that remind us of sunsets and vacations.

Black

In the RGB color model, black is represented by 0,0,0—no red, no green, and no blue—in other words the absence of any light whatsoever. However black should not be dismissed too readily, it needs just as much attention as any other color, and maybe more. If an image is supposed to contain large areas of black, but they appear dark gray, it will weaken the composition by some margin.

Black plays an important role in the vast majority of color images, even in those in which it is not very prevalent, by providing an anchor or reference point for all the other colors. Most images will look far better if they contain the complete range of tones, from black all the way through to white. Making sure that an image has the full spectrum of tones is partly the job of the Levels command (see pages 94-95).

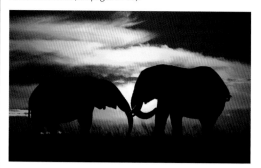

The silhouette is a common use for the color black. In the great majority of silhouettes, anything other than pure black would detract from the impact of the silhouette, which is, after all, concerned with two-dimensional shape and outline.

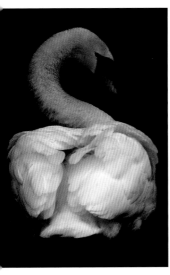

One of black's essential uses is to function as an empty background that, by contrast, throws an object, in this case the beautiful body of a swan, forward toward the viewer.

As a hue in its own right, black can also be used either as a background color, usually providing a distinctive edge to the subject which emphasizes its shape or outline, or as a shape itself (in the form of a silhouette), or even as the color accent in a high-key image.

In most Western societies, black has few positive connotations, often being associated with death, secrecy, and mystery. Only in fashion does black seem to fare quite well. In many other cultures, however, black is often viewed with a positive eye.

White

In the RGB model, white is represented by 255,255,255, which translates as maximum amounts of red, green, and blue. In the additive color model the combination of these three colors creates white.

Like black, white is an important element of most color photographs, both as a counterpoint and setting for the main colors. It also represents the highest of highlights in an image, and its delicacy makes sure that in terms of exposure it must be treated with the utmost care. While most images will benefit from having a white (and black) point (making sure of complete tonal range), careless exposure leading to overexposure will result in large areas of the image losing subtle pale tones to pure white. Pure white contains no tones and therefore no detail. "Blown" or clipped highlights can ruin an image, and should be avoided at all costs. Given the choice between clipped highlights or shadows, in the vast majority of cases clipped shadows will be far less intrusive. This is the thinking behind the adage "expose for the highlights."

White needs other tones and colors to form an image, no matter how pale they are. The subtle and repeated gradation of light gray tones on the underside of the boat is all that is needed to define the ridges in the mind's eye.

Snow, of course, is white, but that also means that it is highly reflective, and to appear pure has to be seen under neutral cloudy light. Any suggestion of blue sky and snow will take on a blue color cast.

As with blacks, exposure is critical with white subjects, and if there is sufficient time, bracketing is recommended. Surprisingly with this image, the extra 1.5 stops (to reveal the door) didn't result in clipped highlights on the white façade of the chapel as was expected. The building was in deeper shadow than the pure white color seemed to indicate.

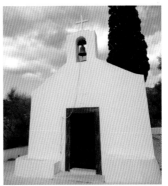

Optical Effects

Having discussed individual colors, and before going on to discuss general color theory in terms of harmony and discord, it's worth spending a short time explaining certain phenomena relating to how our brains process color, as this impacts on how we perceive color.

The two most common phenomena are successive contrast and simultaneous contrast.

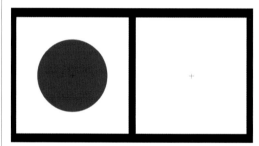

Successive contrast

Successive contrast occurs after you've been staring at a strong color for a lengthy period of time. When you look away your eyes will "desensitize" causing you to "see" the opposite, or complementary color; this is called a negative afterimage. Stare at the cross in the center of the red circle below for at least half a minute, then immediately shift your gaze to the cross in the center of the white space to the side. You will see an afterimage that gradually fades—and the color is cyan. If the circle were green, the negative afterimage would be magenta.

Simultaneous contrast

The other well-known optical effect, and one that probably has greater impact in terms of color photography, is known as simultaneous contrast. In this effect the eye tends to compensate for a strong color by "seeing" its complementary opposite in adjoining areas. The classic demonstration is a neutral gray area enclosed by a strong color. The gray appears to take on a cast that is opposite in hue to that of the surround. Gray surrounded by green takes on a slight magenta cast; gray surrounded by red tends toward cyan. The phenomenon also affects non-neutral areas of color, as the violet and purple pair illustrates. The central squares are identical.

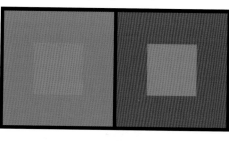

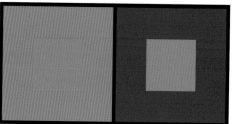

Color Harmony

We know that certain colors work well with one another—they appear in harmony. But do you know what they are, and do you know why they are harmonious?

According to the basics of color theory, there are several ways in which colors look as if they belong together.

Look at the image of the color wheel. Color theory states that colors that sit next to one another, so-called analogous colors, will look good together. Additionally, colors that sit opposite one another, complementary colors, will also appear harmonious. Also placing an equilateral triangle in the color wheel will indicate three colors that work together—these are the color triads. Many theorists extend this to include four-sided symmetrical shapes, such as a square or a rectangle, which when placed inside the color circle, will also provide harmonious colors. Finally, a similarity in brightness (or value) is also thought to create a color palette that works well together, such as pure red and green.

An example of a color circle, as used in the complementary color examples shown opposite, with all the colors visible.

Such color theories are based on "measurable" rules—we can see why they might work. But many other theorists feel that we should just trust our gut instincts or that the place to start is nature. If it exists in the natural world, then it's harmonious.

Over the next few pages we'll look at the more common harmonious color combinations, showing various "real life" examples. However, it's important to remember that our attitude toward color is also formed by our own cultural values and personal fashions. Color theory is not an exact science.

We must also ask why color harmony is important. Why do we want colors to look "nice" together? Shouldn't we also explore colors that are discordant, and examine their impact as well?

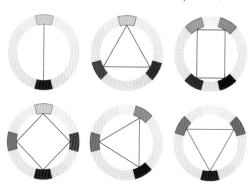

Using a color circle, harmonious color relationships can be worked out very easily. The only requirement is that the colors used are arranged systematically around the circle's center, as indicated by the equilateral triangle and quadrilaterals. Given this, pairs and groups of three, four, and more produce a sense of balance.

Red and Green

With green being the most abundant color in nature, and red not uncommon in plants and flowers, together with the fact that pure red and pure green have the same brightness, this combination of colors fulfils a couple of the color harmony requirements discussed earlier.

In terms of complementary colors, however, a closer inspection of the color wheel reveals cyan, a blue-green color, to be sitting opposite red, and in fact this combination does provide a more balanced result. In addition, you might argue that very rarely do you see pure red and pure green together.

However, there's no doubting that these colors do work harmoniously, even when not in their purest forms, and are considered one of the three classic color harmonies.

In their pure form, that is fully saturated, red and green share the same luminosity, which is one theoretical requirement for color harmony. When juxtaposed they create the effect known as "vibration," which was discussed earlier. The boundary between the two colors appears to flicker.

Orange and Blue

In terms of complementary colors, orange and blue are pretty much exactly opposite one another on the color wheel. Unlike red and green, however, they don't share the same brightness value. Orange is twice as luminous as blue, so to achieve a good visual balance between the two colors, ideally there needs to be twice as much blue in the scene as orange.

In the real world, both colors are frequently found, not least because they both exist on the color temperature scale, albeit

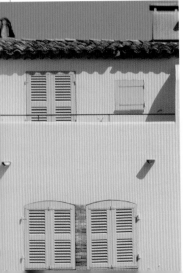

The combination of colors shown here is prolific in the Mediterranean region. Although they are not the true deep blues and oranges of the fully saturated color wheel, they still work as a pastel variation.

at either ends. Orange is the color of sunrise and sunset, candlelight, and domestic tungsten bulbs—the color temperature of which ranges from around 2000K–3500K—while blue is the color of a clear sky and skylight—with a color temperature of around 10,000K. Somewhat confusingly, however, we consider oranges as warm colors, and blues as cool.

Although not as powerful as red, orange is an advancing color, which against receding blues can bring depth to an image—another reason why this color combination works so successfully.

An excellent example of why blue and orange are so common. Taken with the sun low in the sky, the frontally lit cliffs have taken on the orange glow of the sun, while the remnants of the day still reveal a deep blue sky.

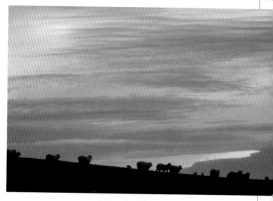

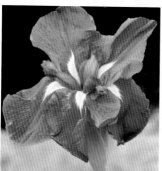

The yellow and violet color combination contributes to the calm, placid feeling in this rural scene.

The violet is one of the rare natural examples of the yellow and violet color combination. The flower also gets the balance of light and dark hues pretty much spot on.

Multicolor Combinations

The more colors present in a scene, the more they fight against one another to be recognized. For multicolor combinations to work successfully there needs to be a relatively large area of each color for it to lodge itself into our consciousness. It also helps if the remainder of the image is made up of fairly neutral hues.

The most powerful multicolor combination is red, blue, and yellow, as dictated by the equilateral triangle in the color wheel. Other complementary colors also work well, but the combination of the brightest color, yellow, with the most advanced and receding colors, red and blue respectively, really helps these colors to stand out.

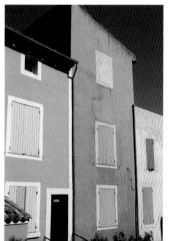

This row of apartments in the southwest of France could have been painted with color theory in mind. Found here are versions of the orange and blue, red and green, and yellow and violet color schemes.

While three colors here cover quite physically large areas—namely yellow, green, and the blue in the table, the fourth color, red, is also conspicuous thanks to its advancing nature.

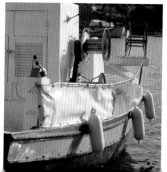

This fishing boat, in the harbor of a Greek island, has been painted with a powerful color scheme.

Color Accent

Images that contain one or more small discrete areas of color that stand out against a fairly uniform background can make powerful and evocative images.

Up to now we've been discussing color harmony, much of which centers around balancing colors in terms of hue and luminosity. Color accent is all about imbalance, when one spot of color is surrounded by a sea of other, ideally, less remarkable colors of more or less the same hue. As our eyes move over the image, they are instantly drawn to the spot of color. That object then assumes a much greater significance than its size would otherwise dictate.

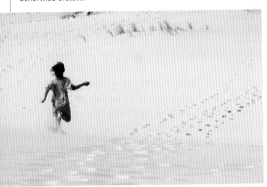

The purpose of this shot was to capture the movement of the boy running down the dune, but zooming out revealed an opportunity to frame one colorful object in a sea of sand. The image also demonstrates a very pale orange/blue harmony.

Taken in late fall, it was unusual to find a leaf that had retained its color while the rest had turned brown. The effect of the color accent here is marginally weakened by the pale leaf in the right of the frame.

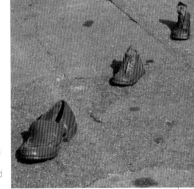

The purpose of these shoes was to direct the audience to a French street artist and political activist.

Color Discord

Any discussion on harmony in color must eventually lead to the opposite of color harmony—color discord.

If color harmony relies on analogous and complementary colors, then it follows that colors that clash must come from a different part of the color wheel, but not the opposite or complementary region.

We also know that the more muted a selection of colors, the more leeway exists in terms of whether they strictly follow color harmony rules; pastel shades for example, can appear harmonious even if they aren't from the right part of the color wheel. So for effective discordant colors, the more colors that are saturated, the greater the sense of discord.

In terms of color, this image should be shouting discord. However, it's natural, so in a sense fulfils one of the harmony categories. So for color discord the assumption is that only artificially colored objects count.

Deliberate color discord reinforces our love affair with pure color, which is particularly strong when we're young. These colors instantly attract the eye; they have positive, bright connotations, and help to sell the doll.

We need to think carefully about what we're trying to convey when capturing discordant colors. Discord has negative connotations in art and music. In the "real world," when photographing objects and people, it's surprisingly hard to find discordant colors. And when you do, it's often intentional, and is purely a way of capturing our attention.

If we do see a scene that we consider unintentionally discordant, such as clothing or interior decoration, it's often a subjective opinion, and one that raises the thorny issue of "good taste." In capturing such images, you may have to confront the criticism, "Who are you to judge anyway"?

It's always useful to learn from a master. In the top color bar, taken from Van Gogh's "Night Café," the painter strived for discord. Compare this with the colors used in "Bedroom At Arles," in which he aimed for harmony.

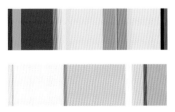

Muted Colors

You may have noticed how color theory deals primarily with colors in their saturated, or near saturated, state. This is primarily because the theories were developed by and for painters using color pigments in their purest forms.

For photographers, who for the most part are photographing "found" objects or scenes, the color palette is naturally far more muted—but no less pleasing for it. Muted colors don't vie for our attention or shout out at us; they tend to create a far more restful and poignant atmosphere.

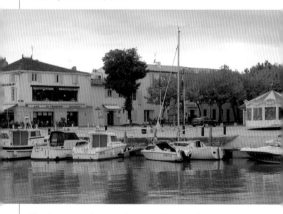

Color schemes are much more muted on the Atlantic coast of France than they are on the Mediterranean. The overcast conditions complement the colors, which are predominantly pale grays and greens, pastel blues, and the russet of the roof.

The muted and restrained color scheme comprising greens and grays allows us to concentrate on the texture and graphic shapes of the composition.

In the South of France, the palette is much more colorful. However, the owners of this row of waterside apartments have all settled for relatively muted, pastel hues.

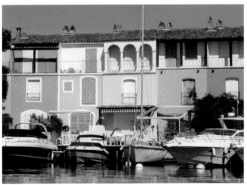

In-camera Controls

All digital SLR cameras have various settings that determine how color is captured. Here are shown Canon's six preset Picture Styles, the effect of each is described below. Other makes of camera have similar settings.

- **Standard**—This is suitable for most pictures, providing vivid colors, and detail that's crisp and sharp.
- **Portrait**—Softens complexions and provides attractive skin tones; an ideal setting for close-up portrait shots.
- **Landscape**—With this setting, blues and greens are slightly saturated, and detail is crisp and very sharp.
- **Neutral**—One of the two settings that are intended for photographers who plan to work on their images on computer. Neutral provides very natural and subdued tones.
- **Faithful**—The other setting for post-production work. In this setting, colors are set to match those of the subject exactly. As with the Neutral setting, results appear very natural and subdued.
- **Monochrome**—As the name suggests, this style converts a color image to black and white.

All the Picture Styles are customizable, allowing you to adjust settings such as sharpness, contrast, saturation, and color tone, the last of which is to adjust skin tone specifically.

Setting Color Space—sRGB vs Adobe RGB

Most digital SLRs allow you to choose between two color spaces; sRGB and Adobe RGB. Although in theory Adobe RGB is a larger color space, capable of rendering more colors, it's only really suitable for people doing all their printing at home, and who have the expertise to make sure their printer and associated drivers are all set up for Adobe RGB. Photos on the internet are displayed in sRGB, and most photo labs prefer sRGB, so it's the safer option.

STANDARD

PORTRAIT

LANDSCAPE

NEUTRAL

FAITHFUL

MONOCHROME

Shoot Raw

If you want to give yourself the best chance of displaying an image at its very best, shoot Raw. A Raw image file contains all the unprocessed data captured by the sensor at the time the photo was taken. It's unprocessed (hence "Raw") in the sense that the camera doesn't apply any image enhancement—such as color enhancement or sharpening—nor does it compress the file to reduce its size. So, while a Raw file may look distinctly "unfinished" straight out of the camera, it does contain more data than either JPEG or TIFF file—with Raw files you have a 16-bit image to work with as opposed to JPEGs 8-bit. This translates as many, many more millions of potentially available colors, which will allow you to improve color and contrast in a much more controlled and selective way, and make many more alterations to the image without it degrading than would be possible with a JPEG or TIFF file. Having a Raw version of your image is also like keeping a master negative, so you can keep going back to make new and different versions of the same image, and your original data will always be available.

The biggest drawback to Raw files is that you have to process them manually to get a useable image file, and that takes time. With JPEGs and TIFFs you can set the level of color saturation, contrast, sharpening, and more, in camera; and as long as the scene is well exposed, you'll end up with an excellent image, one that's comparable with a carefully processed Raw file.

When to use JPEGs or TIFFS

As a rule of thumb, therefore, for family or holiday snaps a JPEG is likely to provide you with perfectly adequate results. For your "works of art," however, particularly those taken in difficult lighting situations, shooting Raw will provide you with the best possible data for making the most of the image.

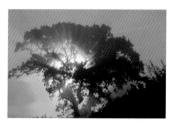

Shooting Raw gives you much greater control over image adjustment than shooting JPEGs or TIFFs. Here, for example, the exposure and white balance are easily adjusted without degrading the image.

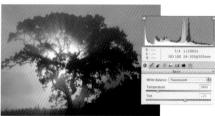

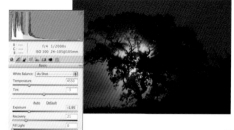

91

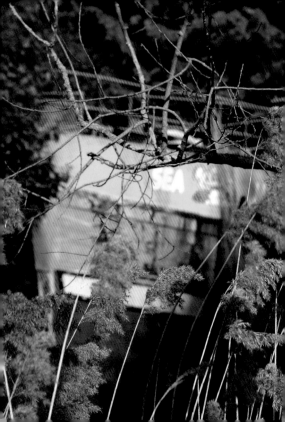

Full Tonal Range

Earlier, during the discussion on white and black, we stressed how important it was for an image to contain as wide a range of tones as possible—from pure black to pure white. Making sure the full range of tones is visible will help to make the image look its best in terms of color and contrast.

Under certain lighting conditions, particularly on gray, overcast days, and when the subject itself doesn't have inherently strong contrast or color, you may find the image straight out of the camera appears dull and flat. While it's likely you can improve things a little in camera, you'll probably get far better results if you optimize it using image-editing software during post-production.

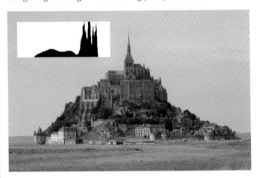

This image of Le Mont St Michel in northern France was taken on a gray September afternoon. The image appears to lack contrast, and the histogram in the Levels dialog window indicates this to be so. There are distinct gaps to the left and right, suggesting an image without very dark or very light areas.

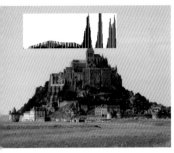

By clicking Auto in the Levels dialog box the darkest color in each channel is made black and the lightest color is made white. As this happens to all three color channels, a shift in color balance can result. Here, the image, although now exhibiting much stronger contrast, has also taken on a blue color cast.

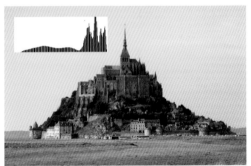

In this version of the image the adjustment was made manually. The black point slider was moved to the right until it aligned with the left-hand pixels of the histogram, while the white point slider was moved left to align with the right-hand pixels. The image looks bolder, but without the blue cast.

Making Color Adjustments

There are any number of reasons why you might want to adjust the colors in an image during post-production. Unless you have to print your images directly from the camera, it's better to shoot with in-camera settings that have colors slightly desaturated or "neutral." That way, when you come to work on your images on your computer, you'll have a greater level of control over color adjustments and enhancement; particularly if you shoot using the Raw format.

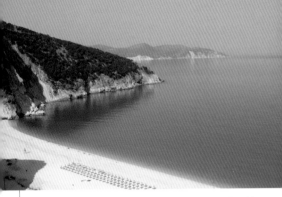

Myrtos beach, on the Greek island of Kefalonia, is famous for its turquoise water. In this shot, the camera color profile was set to Neutral and the Raw format used.

A print using this unedited file would produce a very dull, and inaccurate, result. The trees are a good indication of just how devoid of color the image is.

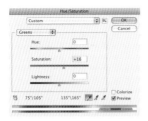

The Hue/Saturation dialog box is the best way to improve colors. Using the Saturation slider you have the option of boosting all the colors in the image by selecting Master in the pull-down menu, or you can adjust individual colors, as shown here.

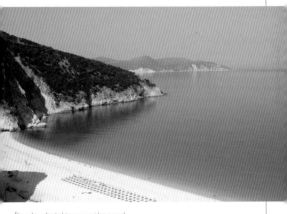

The color-adjusted image provides a much more accurate picture of the color of the sea. Avoid the temptation to saturate colors too much however.

Adjusting Color with Levels

Although we normally think of the Levels command as a way of adjusting brightness and contrast in an image, it can also be used to adjust and correct color. This is because you can use Levels to find the black and white point in all three color channels.

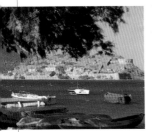

This image has a strong orange color cast, and looks as it if might have been shot with the Shade white balance setting. Unfortunately, the settings have over-compensated and the image is far too warm. If the photo had been taken in Raw it would have been easy to correct this in an appropriate Raw conversion program by applying a different white balance setting. However, this is a JPEG file so can only be fixed using image-editing tools.

Having opened the Levels command, the Red channel has been selected. It's clear from the accompanying histogram that there are insufficient dark red tones in the image. Moving the black point to the right will fix this.

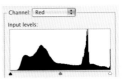

Changing to the Green channel and looking at the accompanying histogram we can see that there are few light green colors. Moving the white point to the left will improve this.

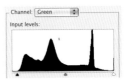

A similar problem occurs with the blue channel—again the problem is insufficient light tones. Moving the white point slider to the left will help.

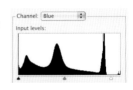

Channel: Blue

Input levels:

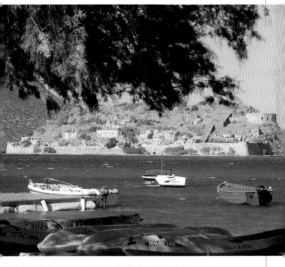

Having optimized each channel in turn, the final result is a much more accurately color-balanced image.

Colorize

While the Hue/Saturation dialog window is used primarily to increase color saturation and to amend specific colors, it can also be used in a creative way. Using the Colorize button in the Hue/Saturation window can provide quick but satisfying monochrome results in a matter of moments.

Here's the image we want to turn into monochrome.

Adjusting the Hue slider allows you to choose any monochrome color you wish.

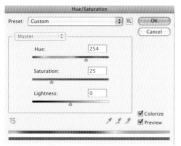

Open the Hue/Saturation dialog and click the Colorize button. The image will take on a single hue, with the Hue slider automatically defaulting to a purple color. At the same time the Saturation slider reduces the strength of the color.

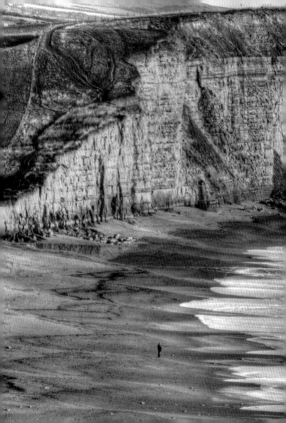

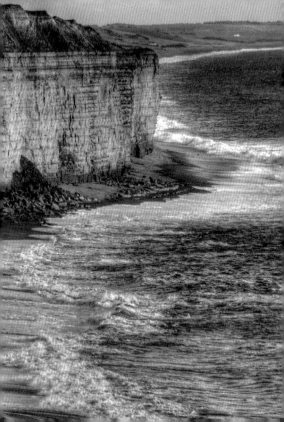

Glossary

Adobe RGB RGB color space commonly used by serious photographers.

Ambient light The existing light in the scene, excluding any light source added by the photographer.

AWB (Automatic White Balance) System that automatically adjusts the color of the recorded picture so that it looks normal to the human eye.

Back-lighting Light source that is on the far side of the subject, in relation to the camera.

Bit The basic unit from which any digital piece of data is made up of. Each bit has a value of either 0 or 1. The sizes of digital files are usually counted in bytes, which are each made up of 8 bits.

Bit depth The number of bits used to record the color of a single pixel. Digital cameras usually use at least 8 bits for each of the Red, Green, and Blue channels, providing a 24-bit depth and 16,770,000 possible colors; some devices offer higher bit depths.

Chromatic aberration Lens fault, common in telephotos, where different shades of white light are focused at slightly different distances.

Clipping Losing detail in the highlights or shadows of an image due to over- or underexposure, or excessive digital manipulation.

Color Filter Array (CFA) The pattern of red, green, and blue filters used over the photosites in an imaging sensor. Usually half the photosites (or pixels) have green filters, a quarter have red filters and a quarter have blue filters.

Color space Theoretical definition of the range of colors that can be displayed by a device or mode.

Color temperature Measurement of the color of light, usually expressed in degrees Kelvin. The human

eye adjusts automatically for color temperature much of the time without us realizing; digital cameras can make electronic adjustments using their white balance systems to mimic the eye and brain.

Complementary colors A pair of colors that create white light when mixed together. The complementary color of red is cyan, the complementary of green is magenta, and the complementary of blue is yellow.

Cyan Color that is a mix of blue and green light. The complementary color of red.

Diffraction Scattering of light caused by deflection at the edges of an opaque object.

Duotone Digital darkroom technique that simulates using two different color inks to print black and white images. Each ink has its own separate curve adjustment, so that some tones appear a different color to others.

Exposure Total amount of light used to create an image.

Exposure compensation A control for manually overriding the built-in exposure meter of a camera to provide more or less light to the sensor.

f number The aperture setting. The number is the focal length of the lens divided by the diameter of the aperture; because of this, larger f numbers represent smaller aperture sizes. The f numbers are used so that exposure settings for a particular scene can be expressed without having to know the focal length actually used.

Filter Transparent attachment that fits in front of a lens or a light source and modifies the light or the image in some way. The term is also used for a wide number of special effects and tools available with image-manipulation software.

Fluorescent light The lighting produced by striplight tubes. The color balance can vary enormously, depending on the type of tube, and manual white balance settings

therefore often offer several fluorescent settings. Daylight-balanced fluorescent tubes are used in some studio lighting systems.

Frontal lighting Lighting directed toward the subject, positioned behind, or level, with the camera.

Gray card Card with an 18% gray tint that is used for exposure metering. A meter reading taken from the surface of the card, rather from the subject, can be used to measure the ambient light levels. This is useful when photographing non-average scenes—such as those that are predominantly black—which would otherwise mislead the meter.

Grayscale A digital black and white image made up of 256 shades of gray tone.

High key An image in which it is the bright, white tones that dominate.

Highlight The brightest areas of an image—the white areas in a picture.

Histogram Graph used as a way of depicting the brightness, tonal range, and contrast of an image during digital manipulation. Also used as a way of evaluating exposure by some cameras.

HSB (Hue, Saturation, Brightness) The three dimensions most commonly used to adjust the color in image-manipulation.

Levels Exposure, contrast, and color-balance tool used in digital image-manipulation. Histograms are used as a guide to the corrections that need to be made.

Low key An image that is dominated by dark tones.

Magenta Purple color; a mixture of blue and red light. The complementary color of green.

Noise Unwanted interference in an electrical signal. Seen as a grain-like pattern in dark areas of a digital image. Noise increases with a digital camera when a higher ISO setting is used.

Pixel Abbreviation of Picture Element. The basic building block of a digital image. The unit of measurement used for determining the

resolution of a digital camera or a digital image.

Polarizer A filter that transmits only light vibrating in one plane. It can be used to deepen the color of part of a picture, such as the sky. It can also be used to eliminate or reduce reflections on non-metallic surfaces, such as water or glass. It must be rotated in front of the lens until you achieve the desired effect.

Raw A native file format offered by all digital SLRs. Image data is stored in a semi-processed state and must be fully processed on a computer. Enables exposure compensation and color balance to be altered after camera exposure, and typically provides a 48-bit color depth option.

RGB (Red, Green, and Blue) The three primary colors used by digital cameras, scanners, and computer monitors to display or record images. Digital images employ the RGB color model, but they can be converted to other color models (such as CMYK) using suitable software.

Skylight filter A UV and warm-up filter combined; sometimes left permanently attached to a lens as a way of protecting the front element from being scratched.

sRGB RGB color space frequently used by digital cameras, but providing a narrower range of colors than the Adobe RGB space.

UV filter Optical filter that absorbs ultraviolet (UV) radiation. Can be used to improve the visibility and quality in mountain and maritime landscapes.

White balance Digital camera system that sets the color temperature for the scene being photographed. This can be set automatically, with the system attempting to set the color so that it looks normal to the human eye. Many cameras also offer manual and preset options.

Index

Picture Credits

Will Cheung 19, 46, 50, 51 (bottom), 59, 60, 89,

Chris George 16, 17, 20, 21, 30, 31, 32, 33, 36, 37,

Steve Luck
7, 8, 9, 11, 12, 13, 14-15, 22, 23, 24-25, 26, 27, 28, 29, 34-35, 38, 39, 40,41, 43, 44-45, 47, 48, 51 (top), 52, 53, 54-55, 56 (bottom), 57, 58, 61, 62, 63, 64-65, 70, 72, 73, 74-75, 76, 77, 78, 79, 80, 81, 82, 83, 84, 85, 86-87, 91, 92-93, 94, 95, 96, 97, 98, 99, 100, 101, 102-103

iStockphoto.com 49 (top; bottom), 56 (top), 71